From
My Kayak...

DONNA LEE TUFTS

3 1969 02637 9411

ה г

PAGE PUBLISHING, INC.
New York, NY

First originally published by Page Publishing, Inc. 2016

ISBN 978-1-68348-689-3 (Paperback)
ISBN 978-1-68348-690-9 (Digital)

Printed in the United States of America

Dedicated to my husband, Peter, my generous friend,
Trudy and my Mother, "Tuddie", who remains in my heart!

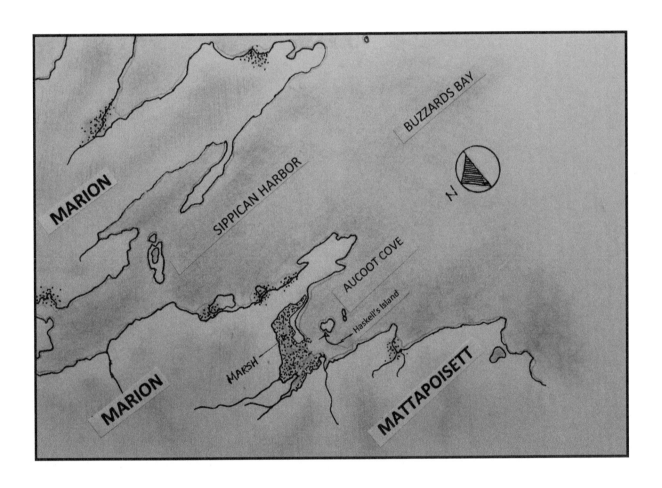

Marion, Massachusetts

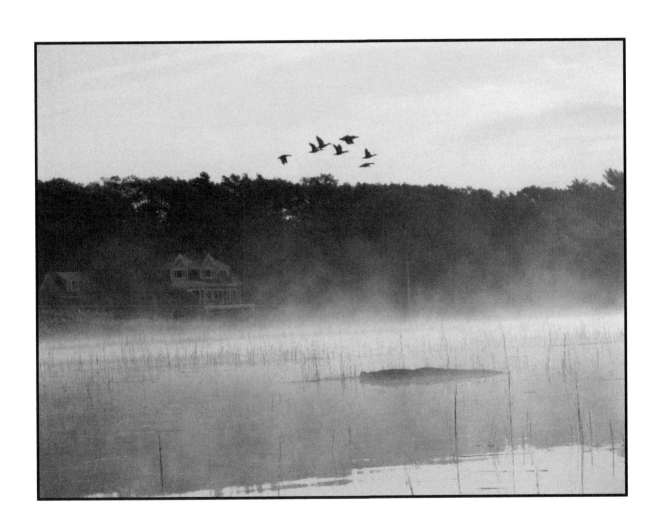

In 2013, a good friend suggested that I take her kayak to use at my residence on Aucoot Cove. I couldn't resist the offer, and even though I had never kayaked, I was able to "Google" the "how to get in and out" part along with the paddling techniques. That's how I came to own my orange "aquaterra" Keowee kayak!

Kayaking gives me the perfect venue for digital photography with my Canon SureShot, getting some good upper-body exercise, and being close to nature and God's creations—which brings me such serenity. More recently, in 2015, I joined a memoir writing group, which is how I came to ultimately write this "coffee table" book, *From My Kayak...*

Let me take you on a journey(s) by kayak. Sit back, look at the photography, read my thoughts and emotions about a simple pleasure available to everyone...

Introduction

Here's a typical example of a morning kayaking…

Rising early to catch the high tide, I complete my stretching exercises before leaving the cozy comfort of my bed. It is early October; the sun is just beginning to rise over Converse Point, and the morning temperature is a bit chilly at forty-four degrees. The wind is light, coming from the southwest this early morning with small, steady waves—a perfect morning for kayaking.

While eating a light breakfast, I look out over the marsh of Aucoot Cove. There's a slight mist, telling me the air is cooler than the water. The once lush, green marsh has been changing its color to golden yellow. In time, this golden yellow will turn to brown and by midwinter, to an almost-black hue. The grasses along the marsh "canals" are tall, and their flowered tips wave in the light breeze, making them a favorite landing spot for small flying insects.

I'm anxious to get outside as I dress in Kokatat pants, a cotton turtleneck, and Polartec jacket. I grab a few articles of clothing: life vest, hat, and a bath towel to keep my legs dry and warm. With my wooden paddles in hand, I'm off to the cove!

It's very quiet… Our dirt road ends in a grass path among dense bushes and small trees hiding the view of Aucoot Cove beyond—but not for long, as the few cedar trees line both sides of the path, which turns into hard-packed sand. The marsh opens up to the right; the backside of the barrier beach comes into view. It is always a welcome sight; it makes me smile.

I continue along the path with marsh on either side. When the tide is at "flood," these marshes become saltwater ponds. You can see, here and there, in the path, dark holes with mounded fresh sand—the signs of fiddler crabs. Water is flowing from the north marsh to the south marsh across the path. At some places, I can walk around the water, and at other places, I must wade through. Although this means getting my feet wet, it is also a sign of the favored high tide.

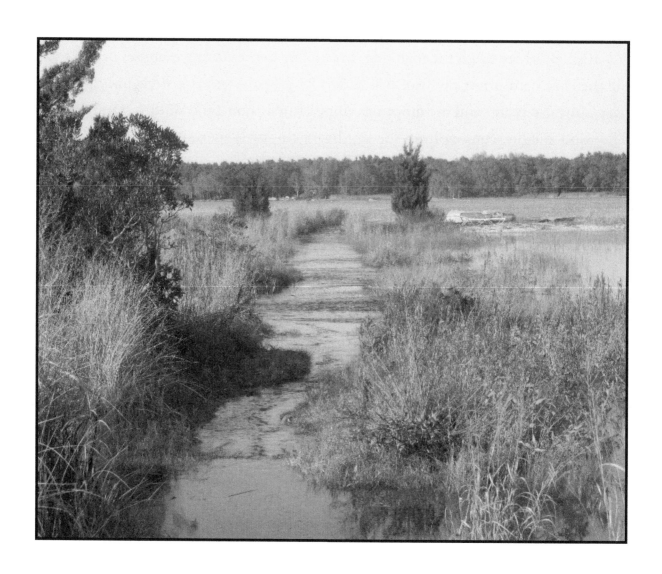

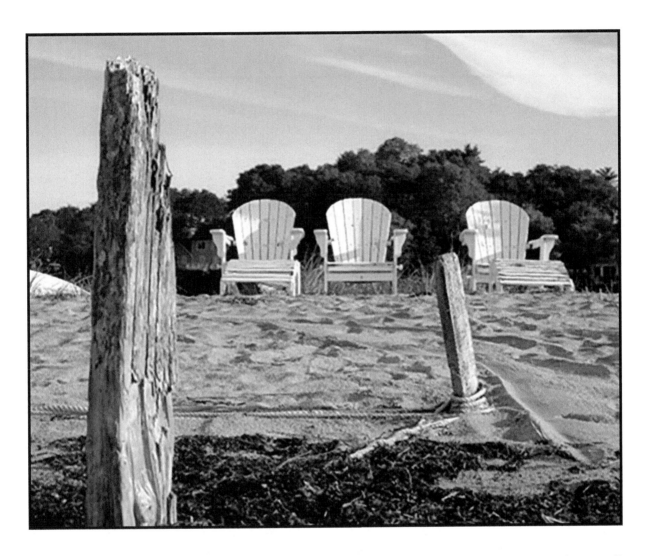

The path turns to beautiful fine sand. Waves lap the beach, rising over the small rocks and washing through the sea grass at the water's edge. Before going to my kayak, I pause, take a deep breath of the salt air, and gaze along the barrier beach. I hear the sounds of Canada geese feeding among the sea grass further down the beach. They're content and feel safe, paired up as couples enjoying an early breakfast.

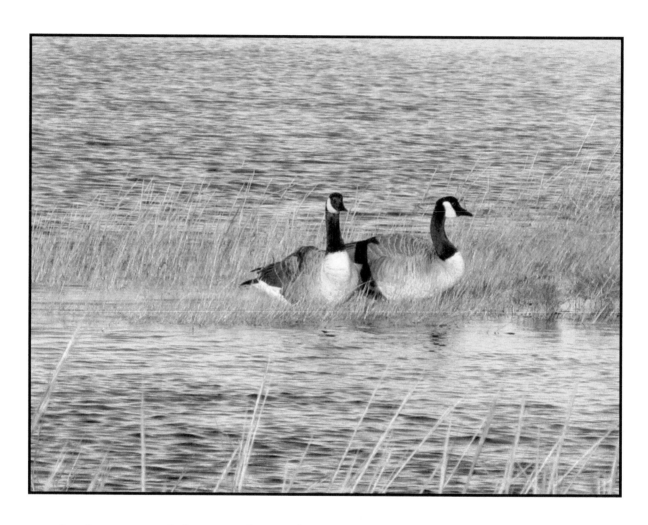

Looking to my left, or southeast, the sun is rising full over Converse Point, making the water sparkle. With a blue sky to the west and the clouds moving away, this will become a perfect fall day.

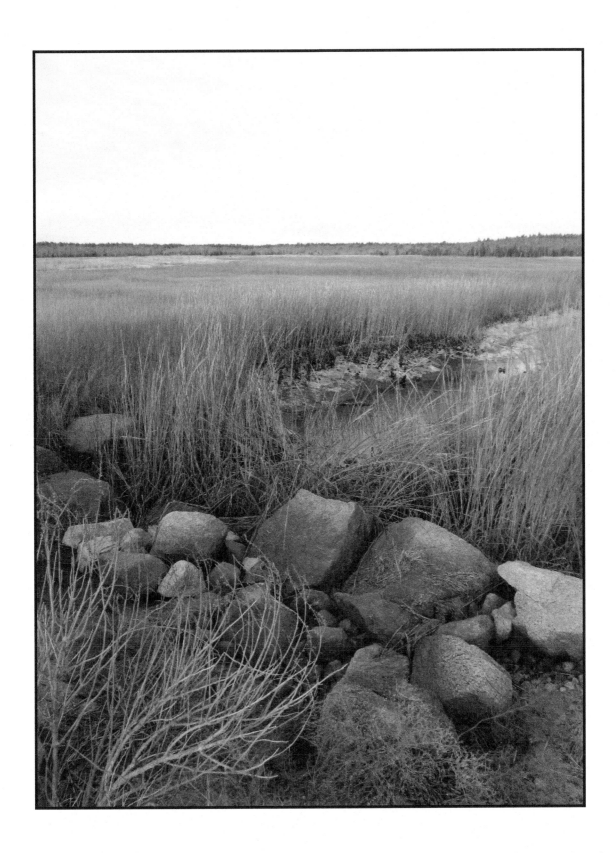

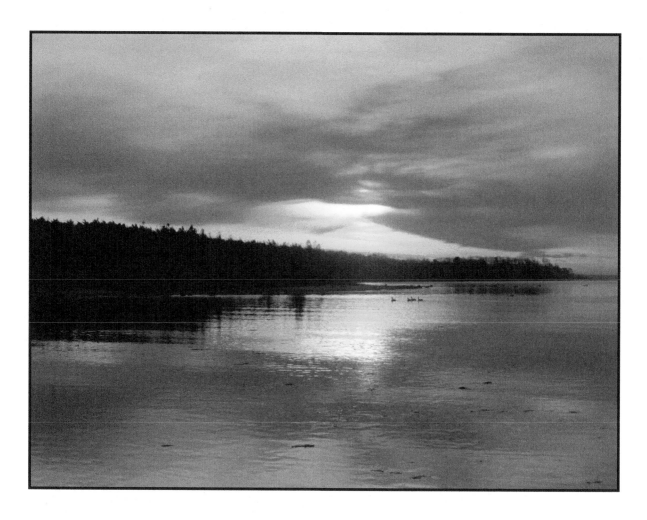

My small, orange Keowee kayak sits upright on the sand at the backside of the barrier beach. She is tethered to a post driven into the sand two and a half feet. If a flood tide occurs with gusty southwestern winds, I know she is secure. There is a black cockpit cover, which became necessary to keep out the critters, like spiders and crickets; it keeps out the rain too. I place my seal bag at the water's edge and click my paddles together, laying it alongside the seal bag and towel.

As I walk to my kayak, I zip up my life vest and place the stopwatch in a top-breast zippered pocket. I carefully remove the cockpit cover and place it where it can't blow away and can also dry off the morning dew. I set the seat back in its position, untie the yellow nylon rope, and then pull the kayak over the sand toward the water.

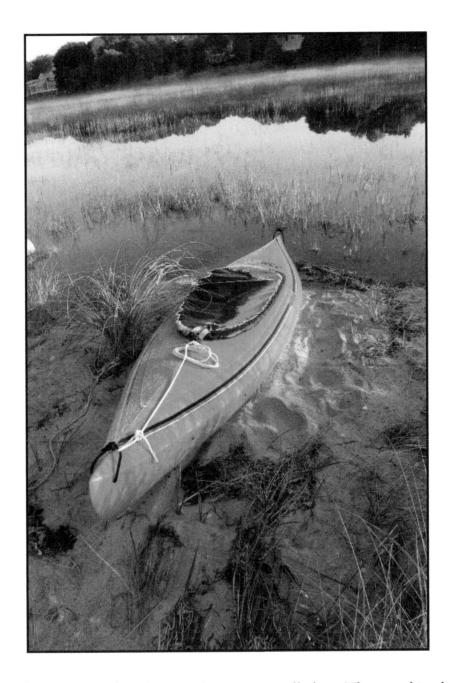

The seal bag is secured with a toggle onto a small cleat. The towel is placed on the back of the seat, still folded, and I grab my paddle.

As I step into the water, I make note of the wind and waves. I feel the water washing around my ankles, then calves, wading until the depth will keep me afloat when I step into the kayak. Balance is key, and I find that crouching low, putting my left foot

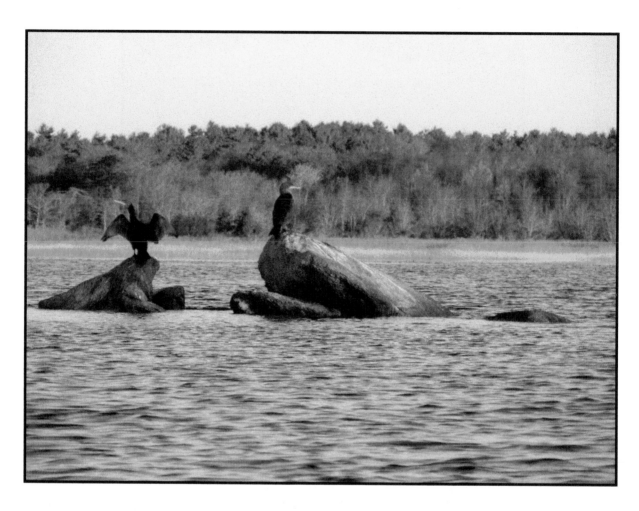

in first and with one movement, sliding into the seat at the same time removing my right foot from the water, and then sliding that right foot into the kayak. It sounds awkward, but the more you kayak, like anything, you get the "hang of it" and do it without thinking. My paddle rests across the cockpit. I place the towel over my knees and legs. This is one of my favorite times, taking that first paddle stroke as I plan my morning's journey in my mind.

The Journey

I decide to paddle out to Haskell's Island. With the light southwest wind, I should make the island in about eight minutes going against the wind. Haskell's Island is located a little more than midway between my beach at the end of Aucoot Avenue and Indian Cove on the west side of Aucoot Cove. It has become my favorite destination to photograph the many cormorants, herons, and other sea and marsh birds. The southern end of Haskell's Island is very rocky with a huge split flat boulder only hidden at flood tide and a trail of rocks, which lead to the actual grass and sand of the main island. At the northernmost end of the island is a sandy beach with some sea grass. A small sandy island is a spot for seagulls, yellow legs, and other birds.

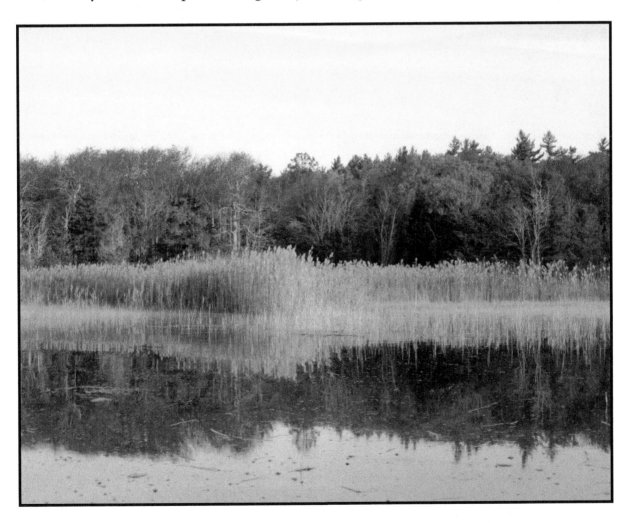

It is usually an easy paddle around the island, being cautious of the many rocks upon which the birds sit facing into the wind. By the end of summer, the rocks have turned white from the bird droppings, and you can smell the stinky "poop" when you're downwind. I love to just float around, taking pictures, trying to get as close as I can without bothering the birds' domain. Sometimes I beach my kayak at the northern end of Haskell's Island and eat my snack or get out to walk about.

As I paddle across Aucoot Cove, I am always aware of the clouds, wind direction, waves, and other signs—which keep me alert of any weather conditions that may cause me to end my kayaking and head to the beach.

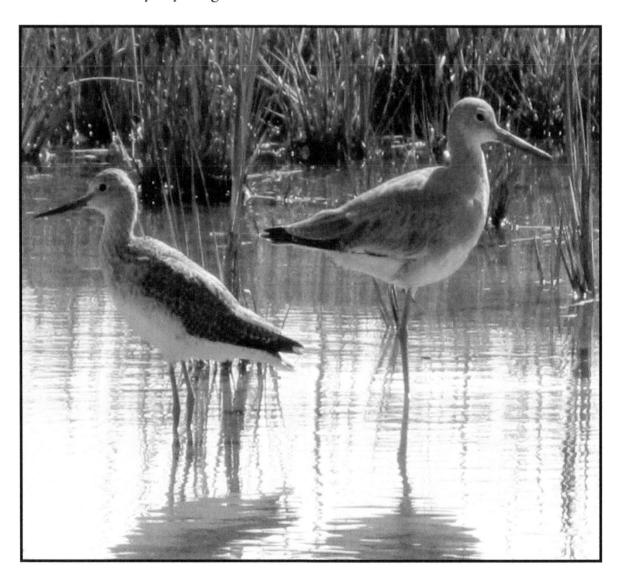

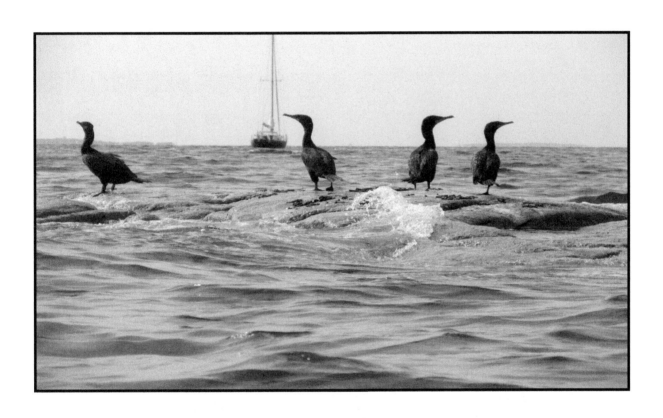

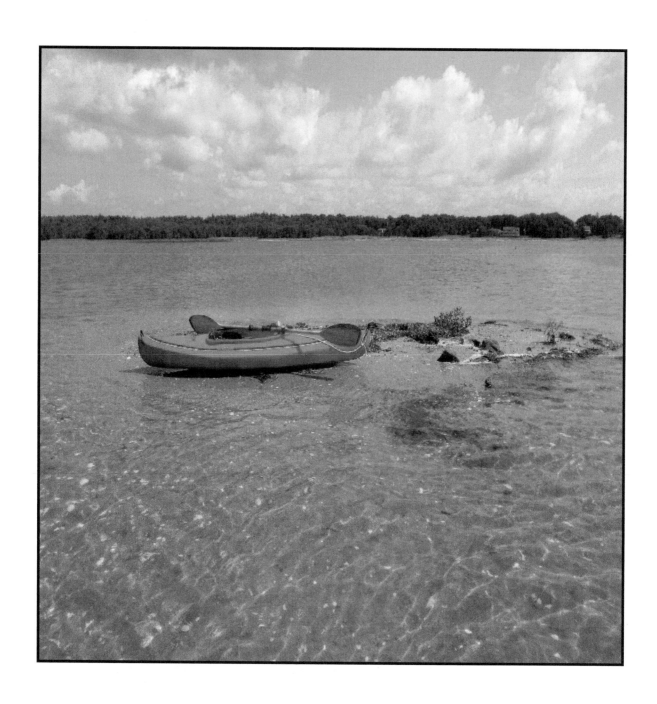

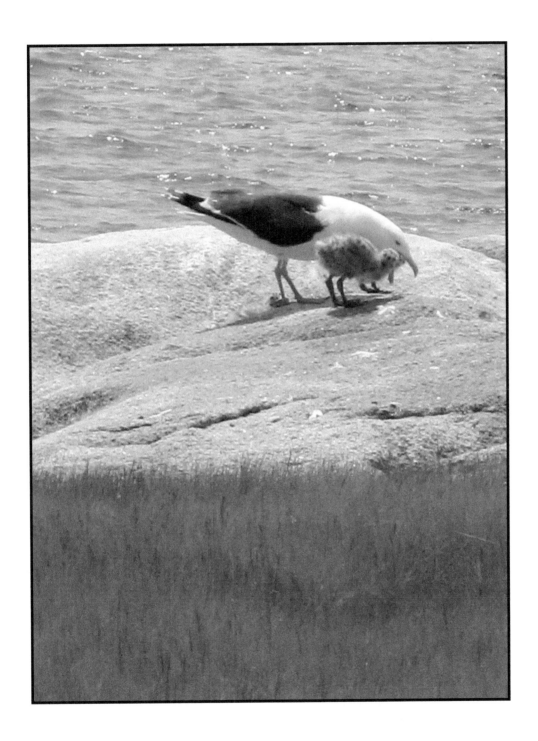

From Haskell's Island, I have several options. I can paddle directly across and into Indian Cove Boatyard and dock, or due north to the osprey nest and one of the largest "canals" of the marsh. I can also paddle northeast to the second largest "canal," leading to the marsh behind the barrier beach.

I decide to paddle across to the Mattapoisett side of Aucoot Cove. There are many waterfront homes, docks, and private beaches on this side, south of Aucoot Boatyard. The landscape and seascape provide many opportunities for photography…

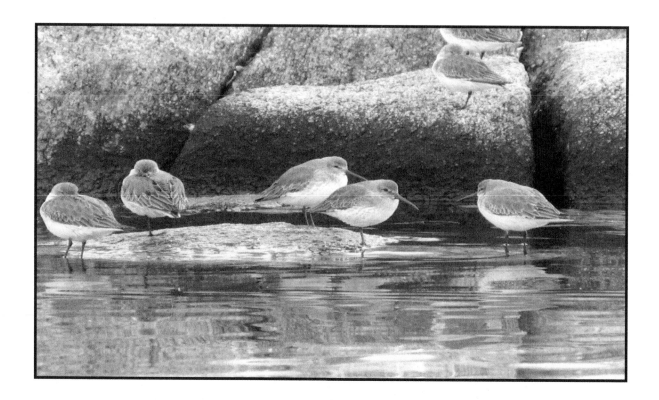

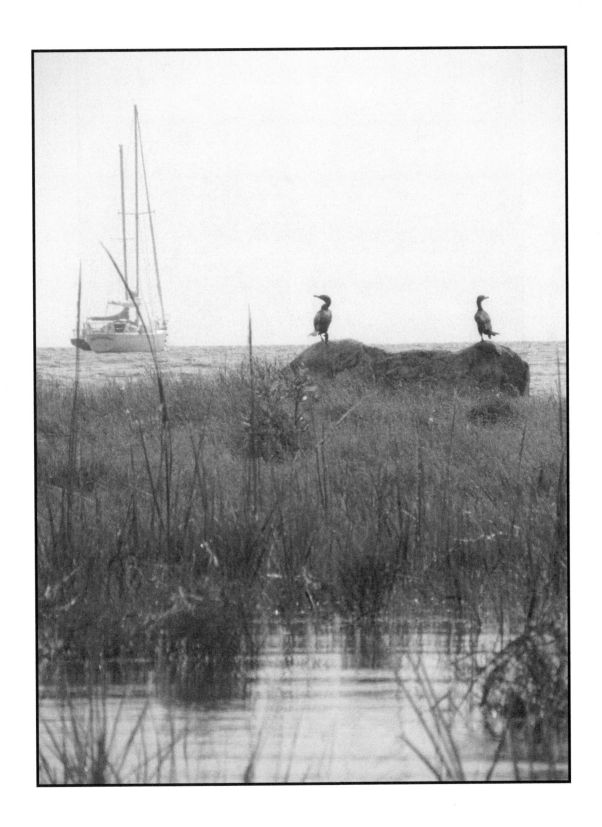

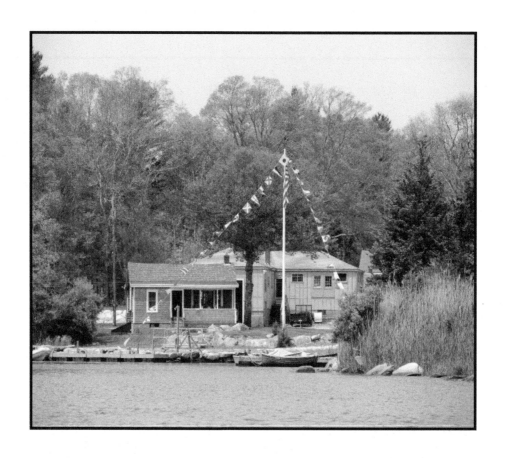

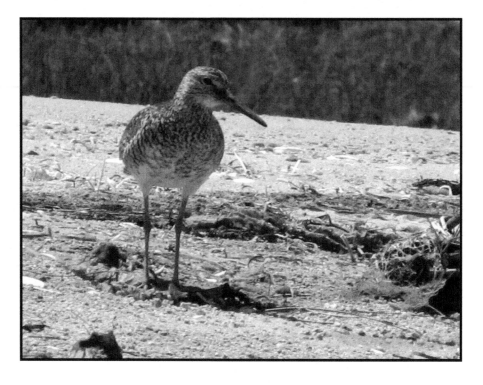

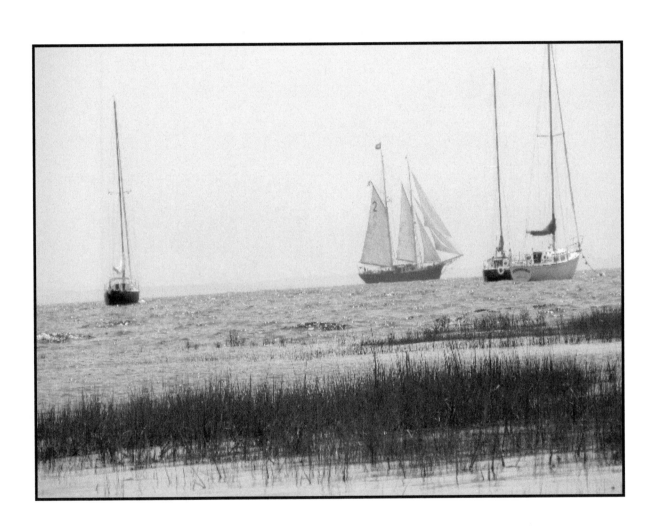

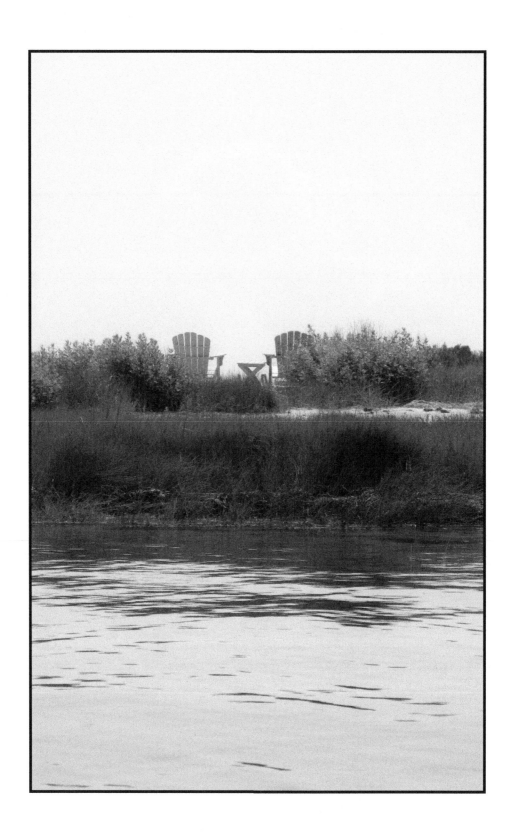

There is a small float at the north side of the Aucoot Boatyard waterway. At high flood tide, the ramp to the float is below the water level, making it an "island." Up ahead, I can see the osprey nest, slightly leaning, but nevertheless, a wonderful "home" for the pair of osprey who arrive each year to have their babies.

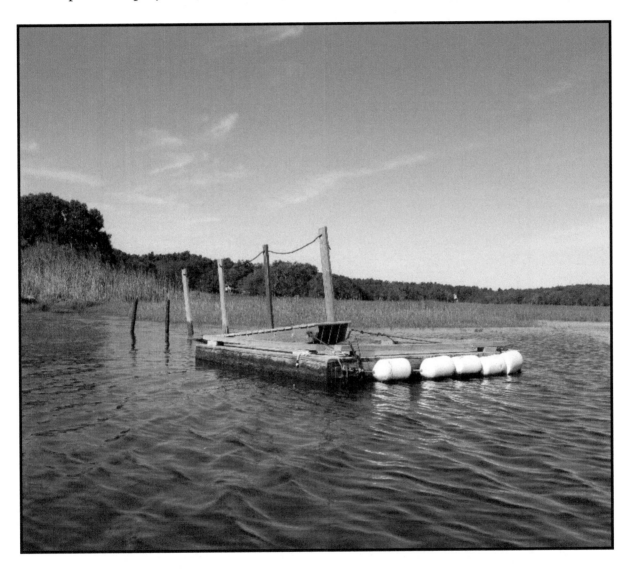

Having traveled along the Mattapoisett side of Aucoot Cove and paddled into the Aucoot Cove Boatyard, I then head to the north end of Aucoot Cove where a large marsh canal houses an osprey nest.

I was once in a prime spot to see an osprey plunge into the water several feet from my kayak and resurface with a fish in its beak. Flying quickly to the nest, the osprey fed its young, hungry babies. This was truly a rare moment, which I will never forget. I felt privileged to have witnessed this spectacle.

It is often on this side of the marsh that I can get close up to marsh birds, if I'm very quiet with my paddling. From green herons, great blue herons, great egrets, and lesser yellowlegs, a variety of marsh wildlife is just several feet away from my kayak.

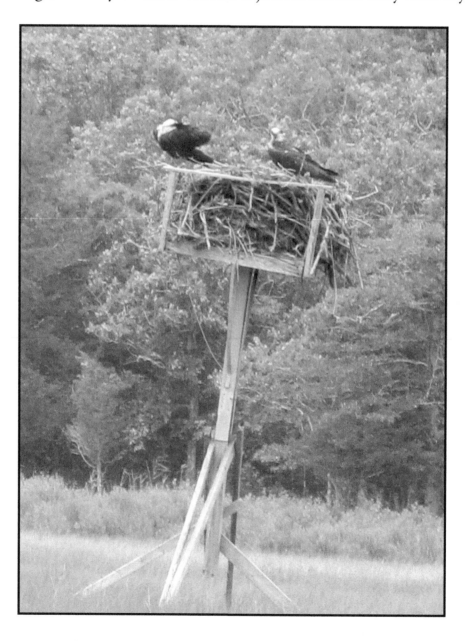

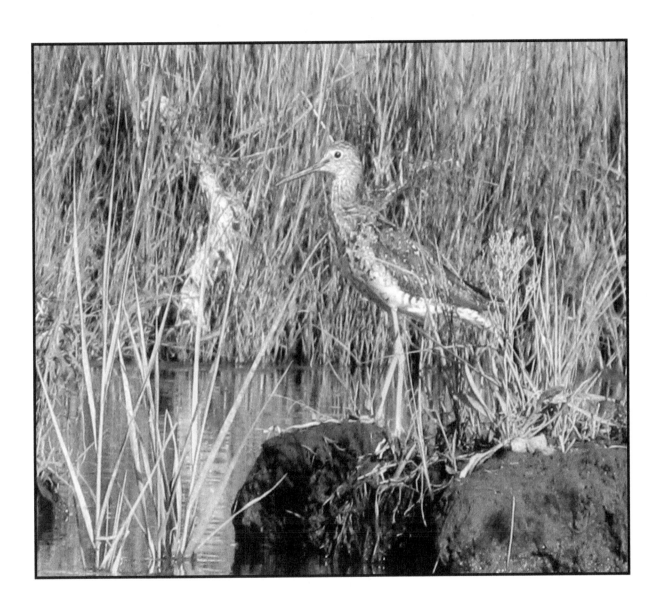

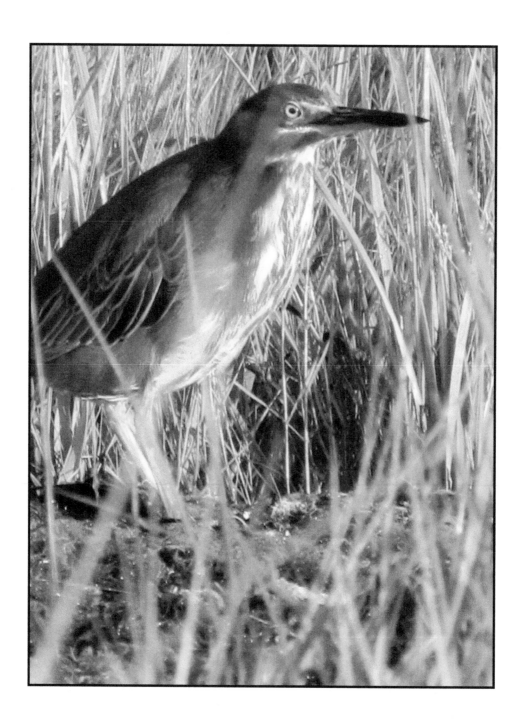

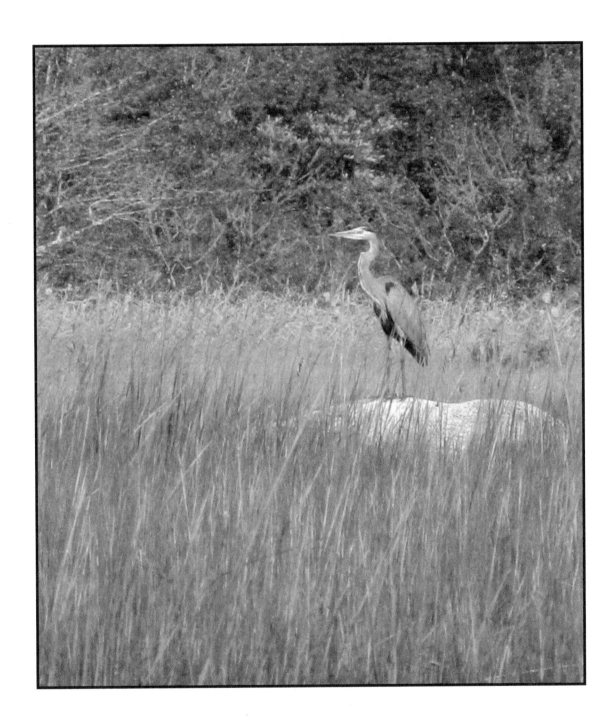

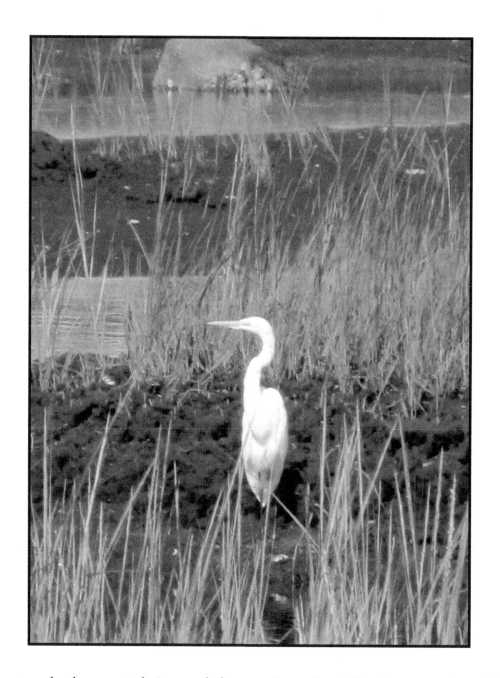

Leaving the large canal, I round the marsh and paddle along its edge. The next largest canal takes me to views of the very north end of the marshlands where the great blue herons sit atop the rocks. One early morning, while kayaking with my brother, Michael, we counted thirteen great blue herons among the rocks. We were so delighted with our "find" and had trouble keeping quiet... smiling from ear to ear, our giggles almost warned the herons of our closeness.

Before heading back to the beach area, I kayak in the flooded marsh behind the barrier beach. There are deteriorating poles, which are the remnants of a pre-1938 wood walkway into the marsh from the old Girl Scout camp off Converse Road. I often tie up to one of these and sit quietly waiting for geese or marsh birds to get close. It's a good place to eat my snack and just relax. One of the private docks, now in disrepair, is only accessible from the marsh at flood tide. It was there that I found my neighbor's "missing" kayak after a storm. You could barely see it with the washed up seaweed and marsh grasses. I was able to reach the "painter," secure it to my kayak's cleat, and tow it back to the beach. A "rescue at sea," so to speak!

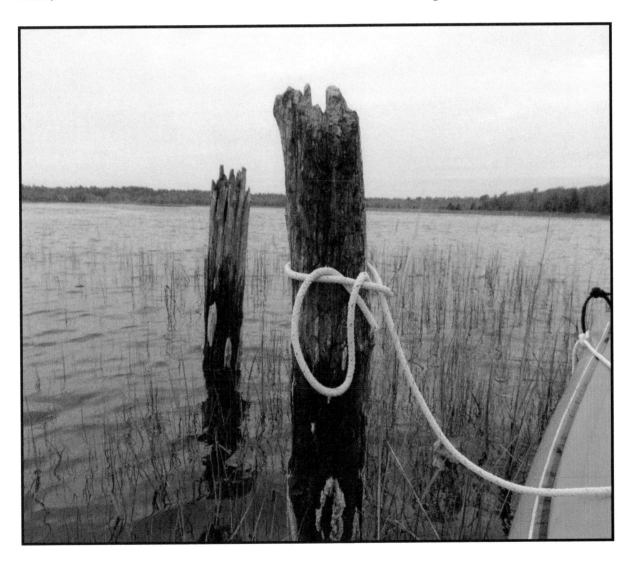

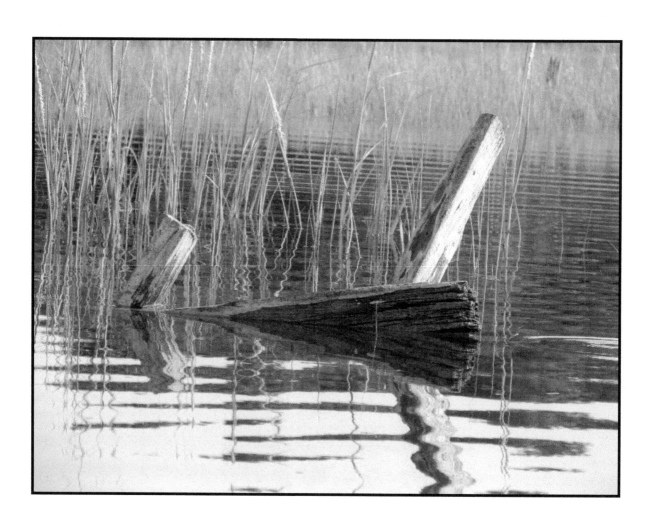

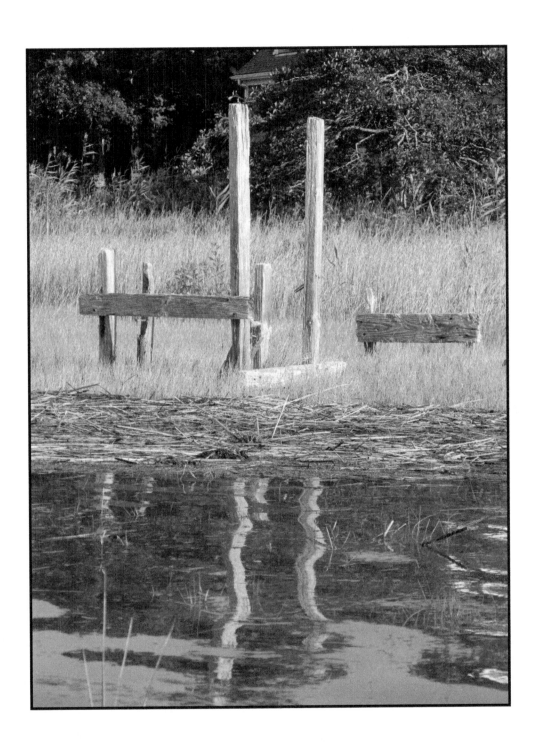

My little rented "cottage" can be seen from my kayak with its reflection in the flooded marsh—very heartwarming and comforting from this vantage point.

I kayak around this marsh, taking my time to enjoy every moment before I head back the way I came to the cove side of the barrier beach.

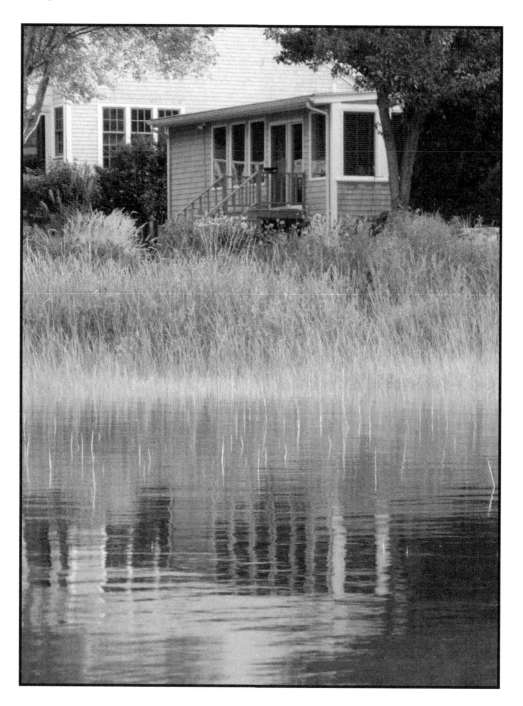

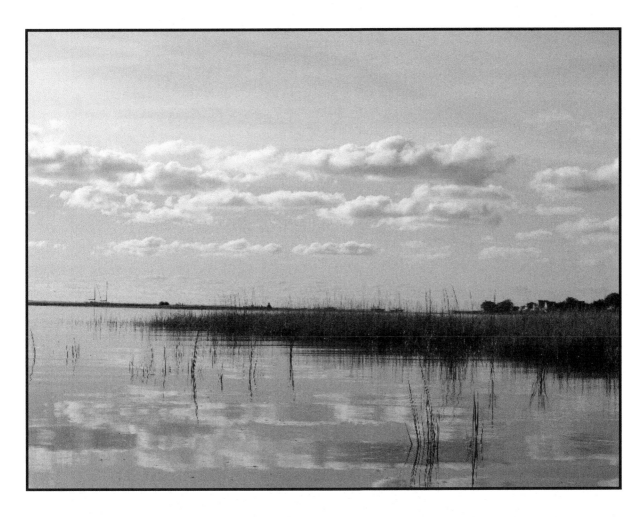

Depending on the weather conditions and the wind direction, I sometimes head to Converse Point before hauling my kayak onto the beach. There, along the west side of Converse Point, are views of beautiful homes, stone piers, rocks, and photographic opportunities.

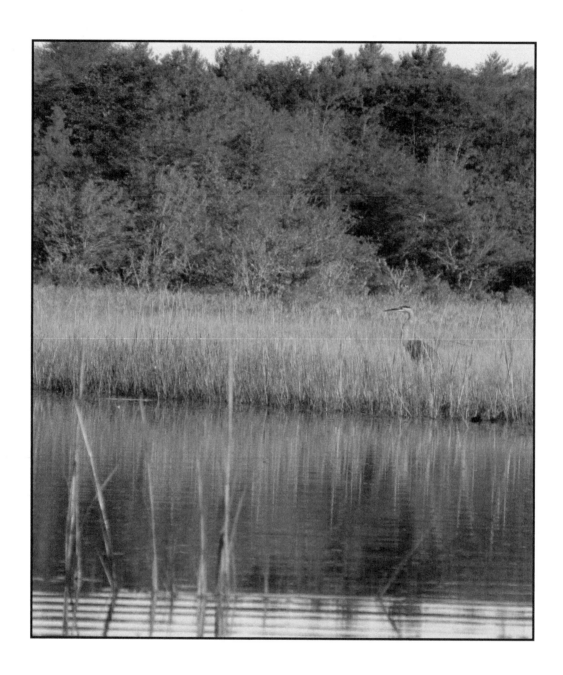

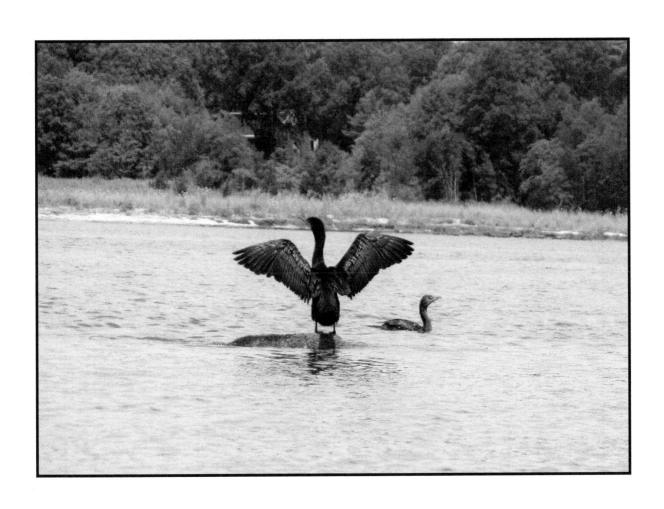

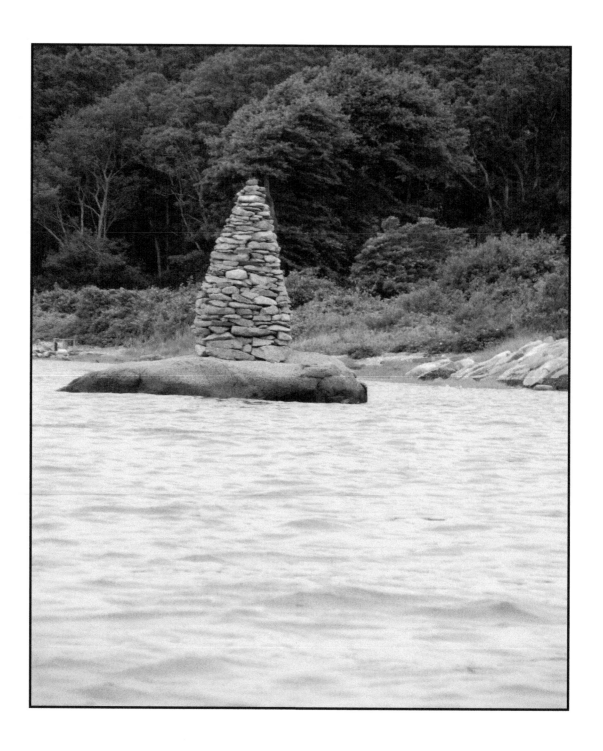

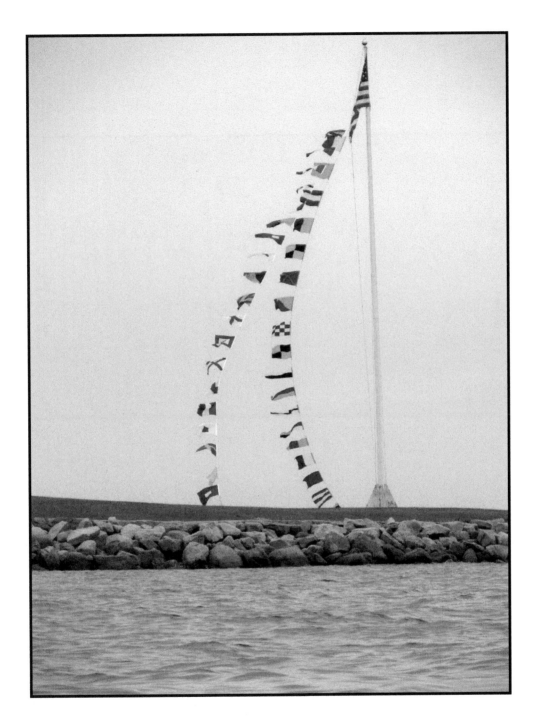

Strong southwest prevailing winds keep the nautical flags at their full display for the Fourth of July weekend at Converse Point.

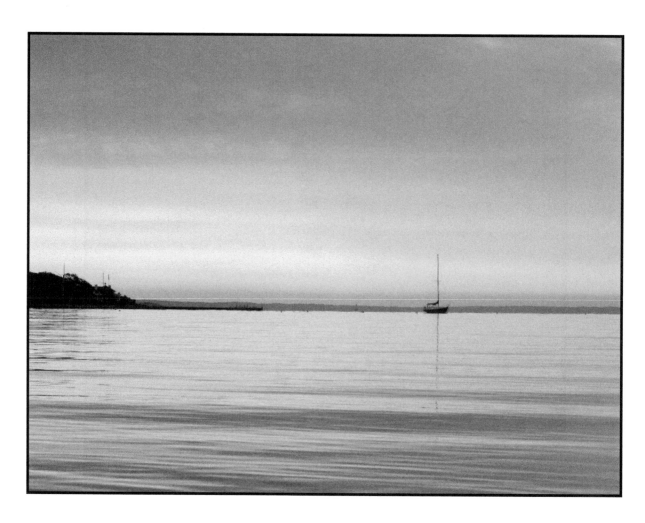

A calm, somewhat overcast, early morning looking south as Converse Point is silhouetted on the left and Falmouth beyond the sailboat across Buzzards Bay.

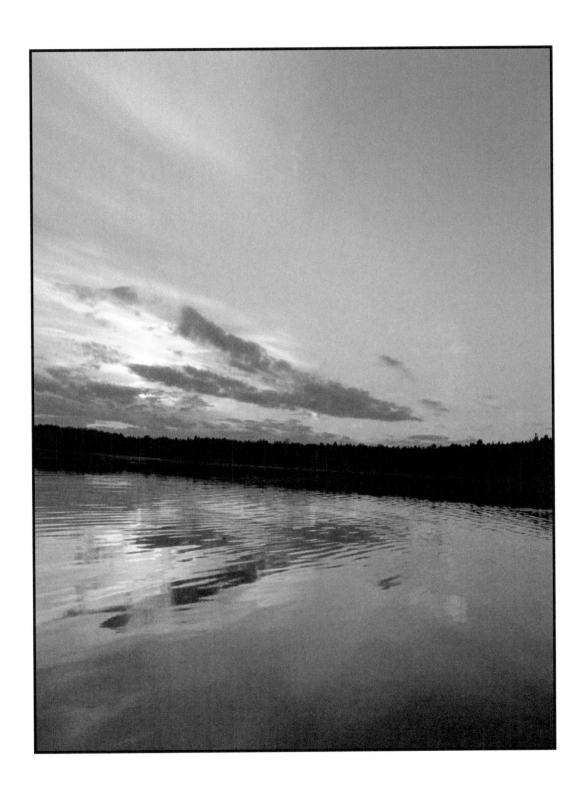

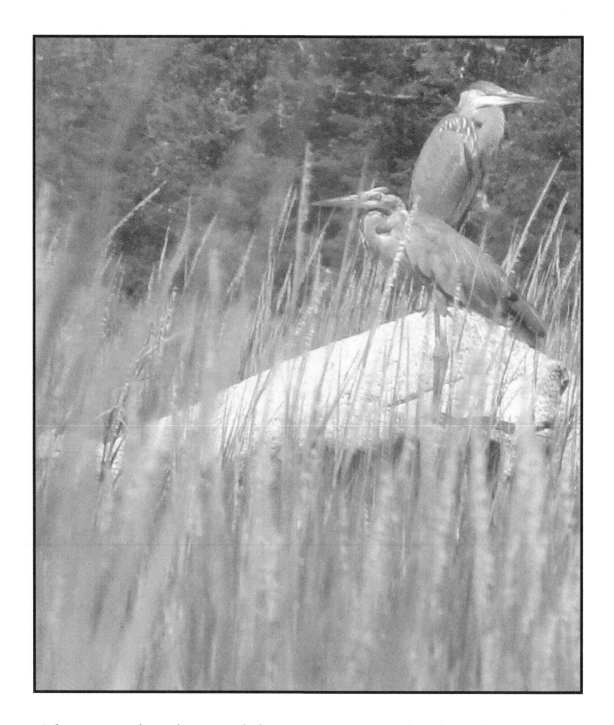

The peace and joy that overwhelms me is awesome. There hasn't been a time when kayaking wasn't enjoyable. Whether a strong southwest wind with breaking waves, or a light breeze with barely a ripple, kayaking is a unique and wonderful adventure. Each year, I look forward to mid-April for my first day kayaking. Bundled up with knee-

high "booties," I am warm, and it's a delight to be back on the water! As the summer months approach, the clothing layers disappear, and kayaking is a way of cooling off in the summer's heat. Then as fall comes around, I again add the layers of clothing. The weather becomes more important in the fall, and I am not challenged with breakers as I am in the summer. Calmer waters and warmer south winds are always welcome in the fall. Usually, my kayaking adventures can last until early December, even if we have an early dusting of snow.

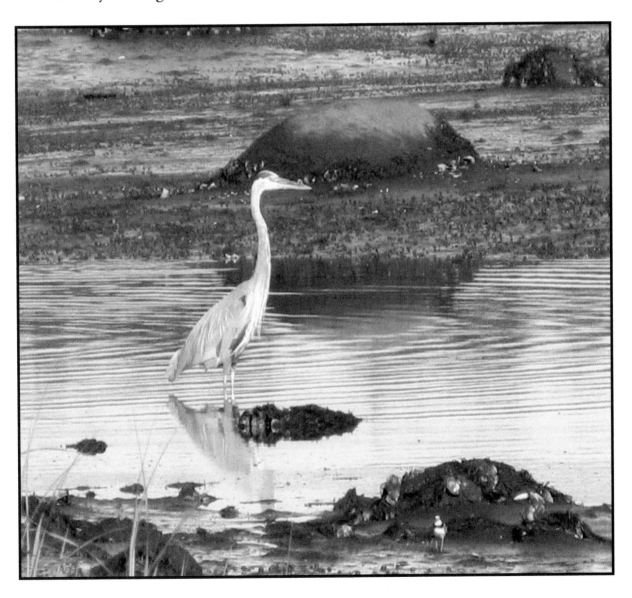

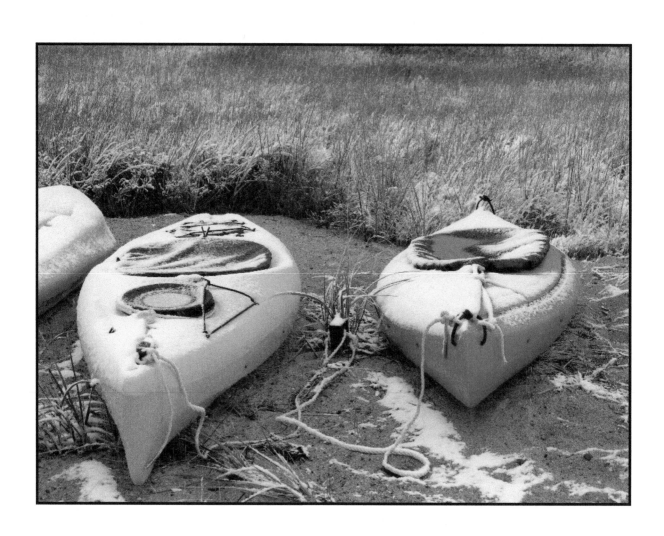

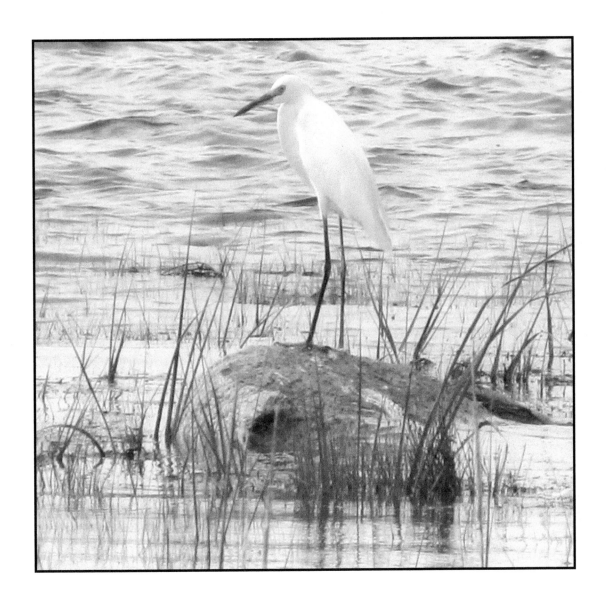

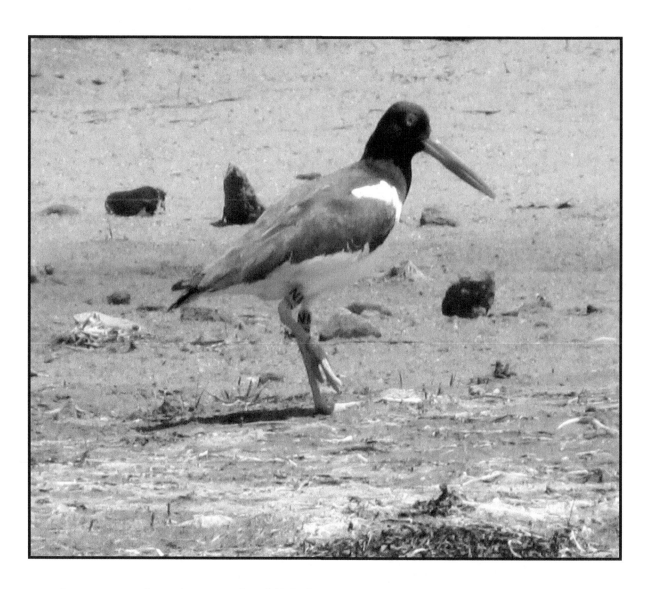

I am amazed at the varied wildlife here in Aucoot Cove! I often wonder if they recognize my orange kayak with each season… like an old friend, I'm back to record them with my digital camera.

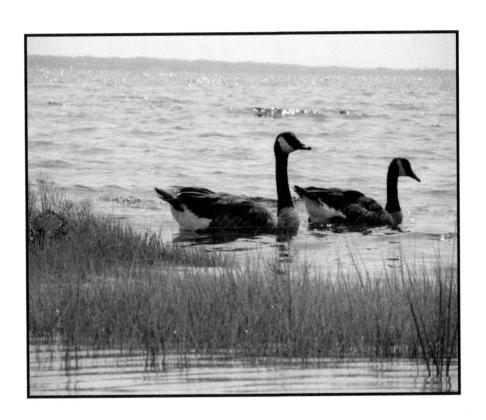

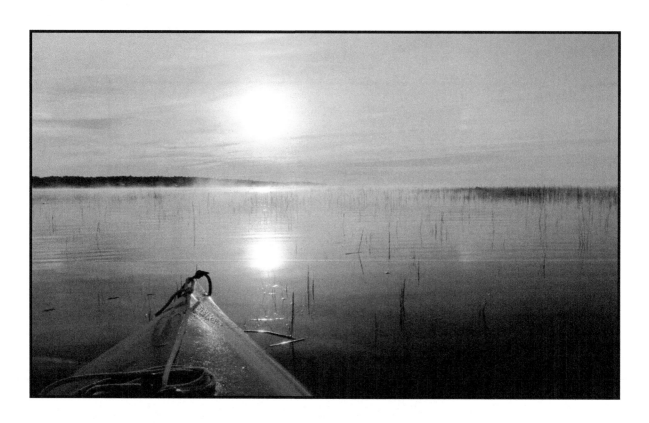

I am so thankful for the opportunity to paddle my kayak, enjoying God's creations. I hope to kayak as long as I can physically and mentally do so. It always leaves me refreshed, blessed, and happy!

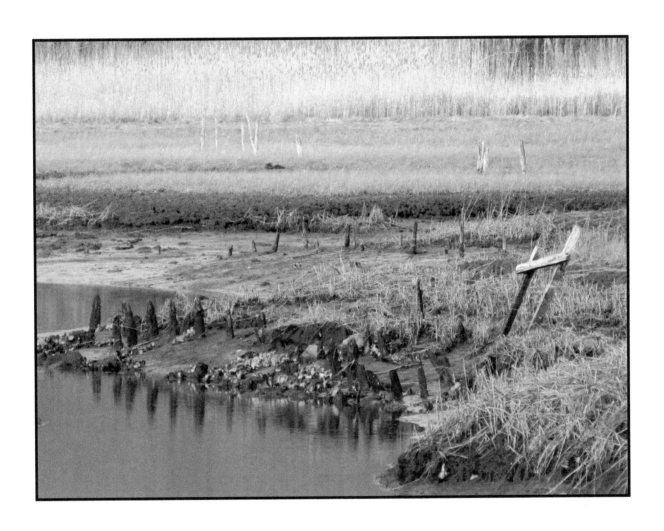

A special "thank you" for all the support from my writing group, family, friends, and my husband who always encourages me to "grow"!

To all the readers of this book, may you find peace, serenity, and contentment as you browse the photos and read my thoughts.

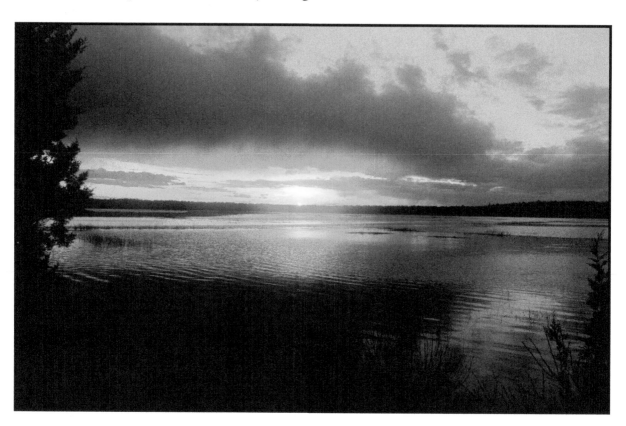

The End... But not the end of my kayaking adventures!

About the Author

Donna Lee Tufts resides in her hometown of Marion, Massachusetts… a place she calls "paradise," only steps away from Aucoot Cove and the marsh. A former public school teacher, Donna is currently a professional interior designer with over thirty years as principal of DL Tufts Interior Design, a photographer, a writer, and Bible study teacher at her church—the Peoples' Christian Church of New Bedford. Donna enjoys being outdoors and especially "on the water"! In addition to kayaking, she likes to read, play tennis, sketch, and have fun with graphic design. Her photography specializes in nature, textures and patterns in nature, and wildlife studies. A lover of animals, Donna not only photographs her "special friends," but also does dog and cat caretaking. Donna shares her life with her husband, Peter—who, for over forty-five years, has encouraged her to "grow."